Playing the Left Hand Guitar

First Edition

Copyright © 2014 Molamudi Mashego / MudiVi Tours

All rights reserved.

ISBN: 978-1-312-01576-0

This work is licensed under the Creative Commons Attribution-ShareAlike 3.0 Unported License. To view a copy of this license, visit

http://creativecommons.org/licenses/by-nc/2.5/

or send a letter to:

Creative Commons

171 Second Street, Suite 300

San Francisco, California 94105

USA

http://www.lulu.com

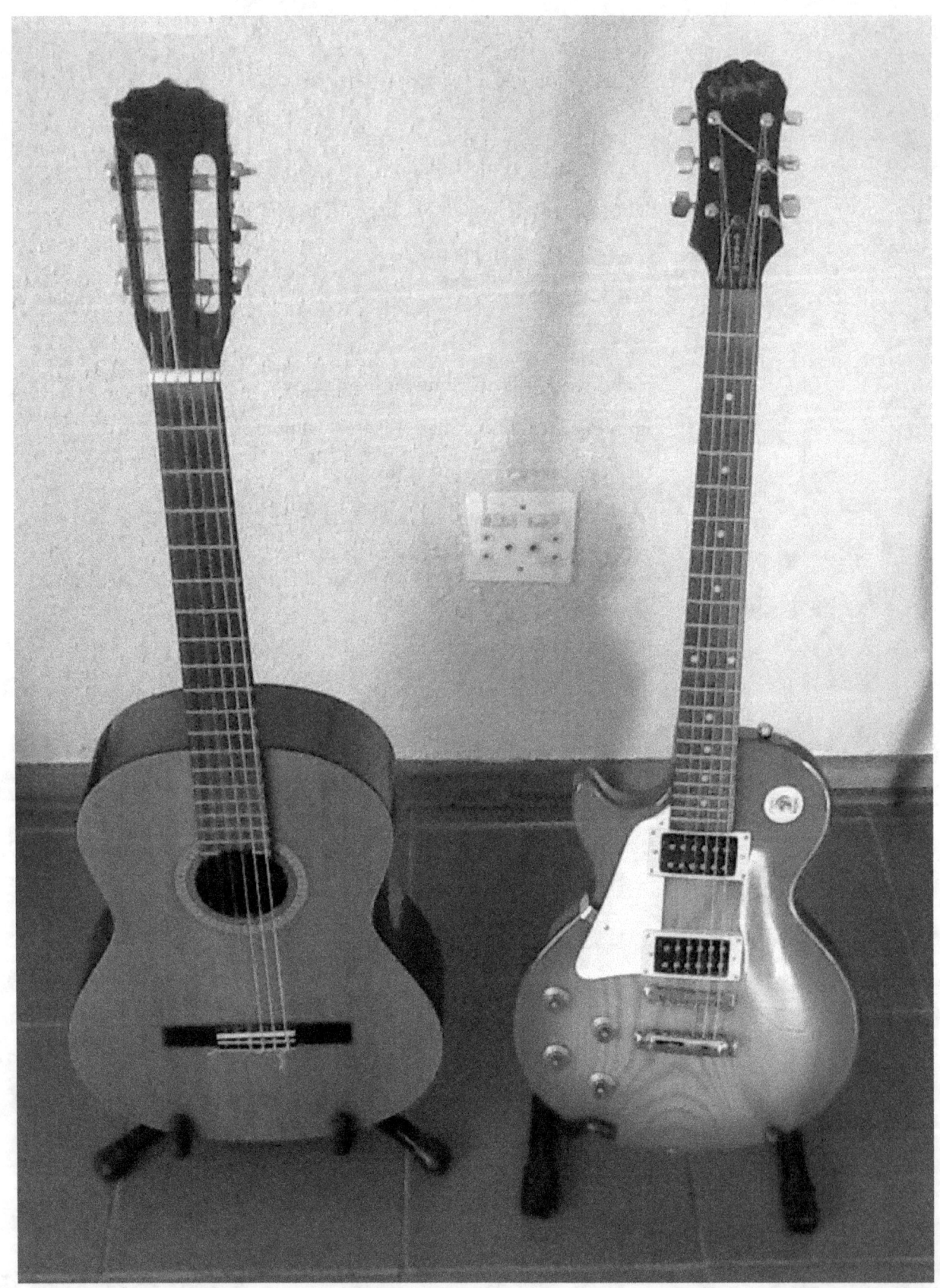

Contents

Playing the Left Hand Guitar ... 1
Introduction .. 5
Left Hand Definition .. 5
Psychological Definition .. 5
Fun Facts about Left Hand Persons .. 6
Famous Left Handers ... 6
History of the Left Hand Guitar .. 6
Famous Left Guitar Players ... 7
Anatomy of the Left Hand Guitar ... 8
Difference between a Right Hand and a Left Hand Guitar ... 9
 Which Left Hand Guitar is Right for You ... 9
 Self-Taught versus Student Guitarist ... 10
The Left Hand Guitar Fretboard ... 10
Tuning the Left Hand Guitar ... 12
Starting to Play your Guitar ... 13
 The Basis of Music .. 13
 Music Alphabet ... 14

Writing Music .. 17
 The Staff .. 17
 Note Value ... 18
 Clefs ... 18
 Time Signature .. 19

Music Theory .. 19
 Pitch ... 19
 Scales ... 20
 The Major Scale .. 20
 Circle of Fifth ... 21
 Circle of Fouth ... 21
 Circle of Keys .. 22
 The Minor Scale .. 22
 The Natural Minor Scale ... 23
 The Harmonic Minor .. 23
 The Melodic Minor ... 24
 Modes of the Major Scale ... 24
 Other Scales ... 25
 Major Pentatonic Scale ... 25

- Minor Pentatonic Scale 26
- Major Blues Scale 26
- Minor Blues Scale 26
- The Diminished Scale 27
- Improvisation 27
- Intervals 27
- Triads 28
 - Triad Families 29
 - The Major Triad Family 30
 - Minor Triad Family 30
 - Diminished Triad Family 30
 - The Augmented Triad Family 31
 - Triads Formed on the Natural Minor Scale 31
 - Triads Formed on the Harmonic Minor Scale 32
 - Triads Formed on the Melodic Minor Scale 32
 - Triads with Seventh Notes 33
 - Major Scale Triads with an Added Seventh 33
 - Natural Minor Scale Triads with an Added Seventh 34
 - Harmonic Minor Triads with an Added Seventh 34
 - Melodic Minor Triads with Added Seventh 35
 - Triad Inversion 36
 - First Inversion 36
 - Second Inversion 36
 - Third Inversion 36
- Chords from Triads 36
- Guitar Chords 37
 - Basic Left Hand Guitar Chords 37
 - Reading the Chord diagram 37
 - Basic Guitar Chords Shapes 38
 - **Chord Extensions** 38
 - Chords Progression 39
 - Chords Substitution 40
 - Basic Chord Substitution 40
 - Useful Chord Substitution 41
- Conclusion 43

Introduction

This eBook is for the left hand who wants to play the left hand guitar or any other person willing to explore the left hand guitar. Many left hand guitar players like Bobby Womack, end up playing the right hand guitar upside down. I personally think playing a guitar upside down is not cool. I used to play a right hand guitar from a friend upside down when I started. I think that was due to lack of information and options to choose from. I played bass guitar initially as I had no teacher and it seemed like a natural thing to do.

My friend got a brand new guitar from his dad as a present and he was showing it off to me and another friend. I borrowed the guitar as I could not leave it alone. My friend made me a thin guitar after he realised that I am not letting go of his guitar.

I was very fortunate that my first guitar mentor who happened to be my guitar friend's neighbour made a left hand thin guitar with a real guitar neck when I was in grade school. I was about nine years old at the time. He told me that I will never play the guitar very well if the strings are upside down. Since that day I always changed the strings of the right hand guitar to make it left hand. I bought myself a true left handed guitar twenty years later.

This book can also be used by the right hand guitar player to learn the guitar from a different viewpoint. It has become apparent to me that when the audience listens they do not have any idea what hand is the player using to deliver the music.

Left Hand Definition

I define the left hand as persons who prefer to write using their left hand. This definition includes persons who are ambidextrous, i.e. persons who can write with both hands very well. The assumption is that if you can read this book you are able to write.

Psychological Definition

Many theories exist today on the origins of the left handed person's existence. The most common one is the Brain Division of Labour theory. The Brain Division of Labour Theory states that inside the head there is a brain. The brain is divided into the left and the right hemispheres. Some tasks like speaking or writing are processed by the right hemisphere while some other tasks are performed by the left hemisphere. The Brain Division of Labour theory states that the left hand person uses the right hand side of the brain. This theory points out that left hand people have a competitive advantage on one on one sport like chess and boxing.

Fun Facts about Left Hand Persons

Here are some interesting facts about the left handed persons:

- About 15 percent of the world's population is left handed.
- Left handers are among the best scientist, artists, architects and distinguished persons.
- Lefties are better at computer games.
- Bill Gates, a leftie was once the richest man in the world.
- Lefties are good at remembering event.
- Lefties process information differently hence good with problem solving.
- Lefties do not think sequentially hence they make excellent fighter pilots.

Famous Left Handers

- Albert Einstein is one of the greatest scientists who ever lived. In his theory of relativity Einstein said you can be older than your parents.
- Leonardo Da Vinci, painter, mathematician and scientist.
- Michelangelo, Italian renaissance painter and sculptor.
- Carlie Chaplin, comedian.
- Spike Lee, music composer and film director.
- Julius Caesar, Roman army general and main character in Shakespeare's play of the same name.
- Neil Armstrong the first astronaut to walk on the moon.
- Henry Ford, the founder of the Ford Motor company.
- Marie Curie, the first woman to be awarded a noble prize in chemistry on her research on radioactivity, she also discovered the elements Polonium and Radium.
- Diego Maradona, greatest footballer of all time.

History of the Left Hand Guitar

The history of the left hand guitar is as mysterious as the left handers. The earliest guitar like four string instrument first appeared in Egypt around 1440 BC. It is not clear if this guitar had a left hand version or if people play left at that time. I can safely guess based on statistics that there were left handed people living in Egypt at the time. Little is known of the music genres of that period. The evidence of the existence of such instruments can be found on stone carving or rock art.

The Cithara was a Roman string instrument that appeared around 1200 BC. Around year 40 BC the Romans introduced the Cithara to Portugal and Spain. The four string guitar was copied from the Cithara around year 1100.The lute became popular in the 1300. Around 1400 the vihuela came into being and became the preferred instrument over the guitar until the baroque period. During the baroque period four and five string

guitar started making the rounds and replacing the vihuela. The baroque period signalled the popularity of the guitar. Before this era the guitar was used for accompanying vocals or other instruments thus the only style was the strumming of strings. As the five string guitar emerged new playing styles like finger picking emerged. The guitar was considered unholy as opposed to the organ and the harpsichord. The rise in popularity of the guitar during the baroque period and the sentiments associated with it can be likened to the rise of the rock guitar. The classical guitar as we know it came around 1900 and the electric guitar was made around 1931.

It is safe to say that left hand persons lived on earth as long as the right hand persons. It is not clear from history that left handed string instrument existed even around 1931. My theory is that left hand persons either learned to use their right hand to play, or play the right hand guitar upside down or changed the strings to suit the left hand. Those left handers that were fortunate hired guitar craftsman to make left hand guitars for them. My first mentor was able to make his own guitars from wood, I mean the whole thing on his own and I doubt he even had any schooling. I am re-inspired, anyway all guitars are made by human beings.

Famous Left Guitar Players

Elizabeth Cotton (5 January 1895 - 20 June 1987): The history of left hand guitar cannot be complete without Elizabeth Cotton. Elizabeth was born Caroline in the USA where she self-taught herself playing the guitar. She was performing and composing her songs at the age of 12. Elizabeth played the right hand guitar upside down this meant that she would play the bass with her fingers and the rhythm and picking with her thumb which is opposite of the normal finger picking guitar playing.

Jim Hendrix (27 November 1942 - 18 September 1970): Hendrix is regarded the greatest guitarist of all time by the Rolling Stone magazine. Jim was born Jonny Allen Hendrix in Washington in the USA from poor and alcoholic parents. Hendrix played right hand guitar restrung for the left hand.

Bobby Womack (04 March 1944 -): Bobby started recording music around 1960 with a family band. He was inducted into the rock and roll hall of fame in 2009. Bobby was born in Cleveland in the USA from musical parents, his mother played an organ at the church and his father was a priest and a musician. Bobby has over 30 studio albums. Bobby plays right hand guitar left hand. Bobby started playing the right guitar upside down without even realizing it. At thirteen Bobby was called to play in a band that was visiting town and did not bring their guitarist along. Bobby also did some gigs with Jimmy Hendrix. Bobby composed and played Breezin' the songs that won George Benson two Grammy awards in 1976.

Sir Paul Mc Cathy (18 June 1942 -): Paul is regarded as the most successful composer and recording artist of all time by the Guinness World Record. His song Yesterday that he composed while with the Beetles has been covered by 2200 artists, more than any other song in history Paul was born James Paul McCarthy in Liverpool in England from a nurse mother and a trumpet playing pianist father. Paul could not play the right hand guitar upside down that he got by trading in his trumpet that his dad has bought him. After seeing another left hand player he changed the strings of his right hand guitar to be left hand. As early as 1962 Paul was performing on stage with a true left hand bass guitar.

Anatomy of the Left Hand Guitar

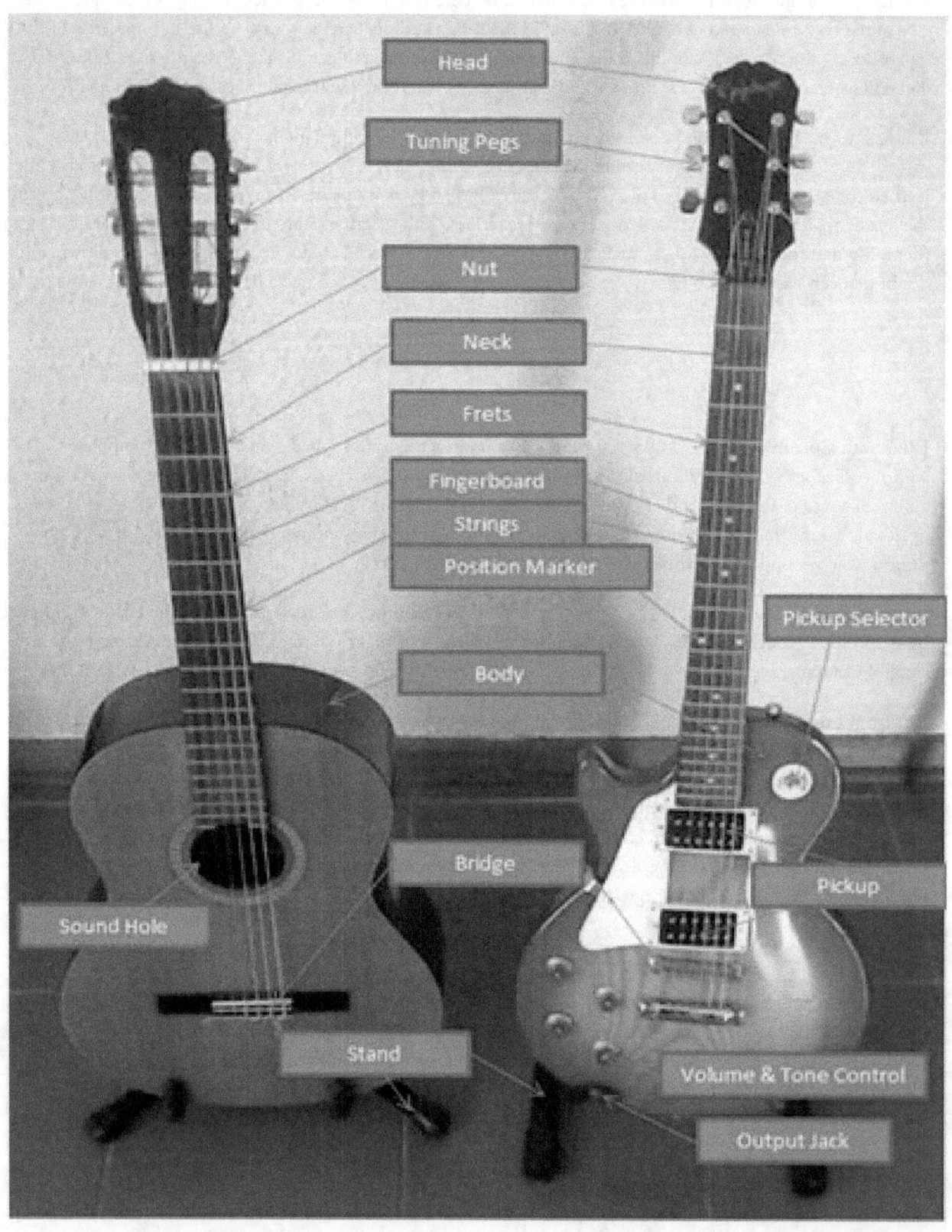

Differences between a Right Hand and a Left Hand Guitar

At first glance there is little difference between the left hand and the right hand acoustic guitar. Most left handed guitarist picked the right hand guitar without realizing the handedness of a guitar, I did. It would be easy to spot the difference between a left hand drive and a right hand drive in a car. The electric guitar is a bit obvious since the pickup will be on the top side for a left hand and the cutaway will also be on top.

The right hand guitar and the left hand guitar have the same shape, length, width, colour; etc. The left hand guitar is usually played on the left lap while the right hand guitar is usually played on the right lap.

Which Left Hand Guitar is Right for You

I do not know what might have come out of my playing had I not played the correctly strung guitar. I think my playing has improved so much I am confident that I can play anything I like to play. Well that has taken some time as well. I think I would still be good in my playing upside down though I think I would have battled fingering most of the basic open string guitar chords.

Left handed guitar are hard to find unless you live in a big city. Even if you live in the city most of the music shops may have one or two left hand guitar out of hundreds of right hand guitar. Another dimension is that the left hand guitar is a bit pricey on the same range or model. I personally experienced this. For more than ten years a certain shop had only one left hand guitar and the guitar happened to be a type that I do not like. I always wanted a hollow body jazz guitar.

Do not despair as I think there are other ways and means you can use to find your guitar. The simplest and easiest way is to change the strings of the right hand guitar. Yes I know this may not be the best option but at least you can start playing the guitar correctly. The disadvantage of just changing the string is that the tone may not be aligned since the bridge is slightly tilted to allow the best possible tone.

Another way of getting the guitar of your dreams is to ask the music store to order it for if they are willing. This may be at an extra cost. Ordering a guitar through the music shop will simplify the process of buying international items and the customs regulations associated with it. I will not mention the taxes and the bureaucracy that normally come with foreign purchases.

Another way of getting your dream guitar is to order it yourself preferably over the internet. I ordered my Epiphone dot jazz box over the internet and not from the shop but from a guy who was selling the guitars on eBay. I may just add that I have ordered books as well over the internet. The internet is the future. The internet is also a future shop, future everything and it is a good place to research and find the guitar that you want to buy. The big risk associated with the internet can be reduced by a good research and possibly some references from the people you know who know about the product you want to buy and the channels you a buying it from.

Self-Taught versus Student Guitarist

I define a self-taught as a garage guitarist who initiated the guitar learning by playing and self-teaching while the student guitarist or academic is someone who had some coaching from another person or even attended some formal training on the guitar. Regardless of how you have started I think the average guitarist has both self-taught and student guitarist qualities.

You are a garage guitarist in that you picked up a guitar and started to play without waiting for a teacher to lead your development. Learning the guitar this way can be the most challenging because you have to worry about tuning, and what to play among other challenges. It is also the very fulfilling as you know you taught yourself how to play. I am glad the guitar is not a car because learning to drive a car self-taught can endanger your life and others, besides it is illegal.

You are a student guitarist in that you realized that you needed a book or someone to guide you in your music journey or you might have asked a friend to show you some moves on the guitar. A student guitarist can also learn by watching other guitar players. The student approach to music is recommended as it eliminates the many challenges you might face trying it on your own and it may also save some time.

The Left Hand Guitar Fretboard

The fretboard of the guitar has reached its finest and I do not foresee major changes on the guitar fretboard but I foresee changes on the number of strings the guitar may have. The sizes of the frets are scientific as well as the length of the fretboard. You may notice that as you move from the tuning head to the body of the guitar the frets get smaller; this means that at a certain distance from the tuning head the frets become unplayable. The longest fretboard has 24 frets.

The left hand guitar fretboard is a mirror opposite of the right hand guitar. The Left Hand Guitar Test: If you place the guitar on your left lap and hold the neck with your right hand, then if the bass string on the fretboard is close to your head and the smallest string closest to your leg the guitar strings are arranged for the left hand. Remember that the strings always increase in size from the smallest to the biggest.

Photo: The left handed guitar fretboard.

Image: The left handed guitar fretboard with notes highlighted.

F		G		A		B	C		D		E	F		G
	B	C		D		E	F		G		A		B	C
	E	F		G		A		B	C		D		E	F
	A		B	C		D		E	F		G		A	
C		D		E	F		G		A		B	C		D
F		G		A		B	C		D		E	F		G

Image: The left handed guitar fretboard with notes, strings and frets labels highlighted.

	1	2	3	4	5	6	7	8	9	10	11	12	13	14	15
6E	F		G		A		B	C		D		E	F		G
5A		B	C		D		E	F		G		A		B	C
4D		E	F		G		A		B	C		D		E	F
3A		A		B	C		D		E	F		G		A	
2B	C		D		E	F		G		A		B	C		D
1E	F		G		A		B	C		D		E	F		G

The left handed guitar strings are named by symbols and numbers starting from the smallest to the biggest. The smallest string is called E and is numbered one. The number and name are often combined as 1E for a single representation. Using this notation we call the first or smallest string 1E, the second smallest 2B, the third 3G, the fourth 4D, the fifth 5A and the sixth and the biggest 6E.

TIP: The guitar fretboard should not be learned in isolation but used and learned while mastering the scales.

Tuning the Left Hand Guitar

It is not all music instruments that need tuning. A trumpet, saxophone and keyboard do not need tuning as they are tuned from the factory. The guitars need periodic tuning and my personal opinion is that you need to tune the guitar every time you need to use it. Guitar tuning for me is the key to learning and developing guitar skills because when the guitar is not tuned all what you know how to play will not work. You have to learn what you already know all over again.

The are many types of guitar tuning namely standard tuning, open tuning, major tuning, minor tuning etc., I will focus only on standard tuning. The standard tuning has the strings tuned 6E 5A 4D 3G 2B 1A. 6E means that you tune the sixth string to an E note by adjusting the tuning head. There are many ways to standard tune the guitar and all the tuning methods are not specific to which hand you are using. Here I explain five different ways to tuning your guitar.

The first method is that you can ask someone to tune the guitar for you. Well this is the simplest way of tuning as you only need a confirmation from the person who is tuning the guitar for you. I was able to tune the guitar at an early age, when I was about twelve years old I used to charge my handful of friends a fee to tune their guitars for them. I use to tune by ear at that time. Any skilled guitar player can tune the guitar for you probably for free and very quickly.

The second method is that you can tune by ear. The guitar has six strings labelled from the smallest number one to the biggest number six. The notes of the open strings are named from the smallest string to the largest E B G D A E. The smallest string is called E and is labelled 1E. The next string is labelled 2B, the third string is labelled 3G, the fourth string is labelled 4D, the fifth string is labelled 5A and the sixth and biggest string is labelled 6E. Note that the 1E and the 6E differ in pitch or frequency.

If you hold the note on the fifth fret of the 6E string, it should sound the same as the open string 5A, if it is not the same you tune the 5A string to sound like the note on the fifth fret on the 6E string. When you hold the note on the fifth fret on the 5A string it should sound like the open string 4D. When you hold the note on the fifth fret of the 4D it should sound like the open string 3G. When you hold the note on the fourth fret on the 3G it should sound like the open 2B, this is the only exception all the other strings work on the fifth fret. When you hold the note on the fifth fret of the 2B it should sound like the open 1E. Remember we are tuning from the sixth string to the first string with the assumption that the sixth string is already in tune. This tuning method does not have to happen in sequence as I have explained it but requires that you tune to nearest adjacent string at a time. This method relies on tuning by ears as no devices or instruments are used. Tuning the guitar by ear helps in your music development. I recommend you tune the guitar by ear then use a guitar tuner to confirm the tuning.

Another method of tuning your guitar is to use another instrument that is in tune. Using another guitar is easy and effective as you compare each string of your guitar to a similar string of the tuned guitar and adjust your tuning to fit the tuned guitar. You can use any other instruments with comparable range of notes as the guitar for example a piano. When you use any instrument other than a guitar you need to know which notes on the other instrument to compare them with the six guitar strings or any note of each of the six strings.

Finally you can use a device or machine to tune your guitar. Analog tuners like tuning forks or commercial tuners are readily available in most music shops. A tuning fork sounds only one note. You can buy six tuning

forks, one for each string or you can buy one and tune one string and then use the tuned string to tune the rest. Analog tuners can tune all individual strings one at a time. Electronic and digital tuners are also available. The iPhone has many apps that can help you tune your guitar.

Starting to Play your Guitar

The Basis of Music

Starting to play the guitar can be the most challenging thing to do but it does not have to be that way for you since you have this book to guide you in your music development journey. I am going to explain why this book is the easy way I know to get you started on the guitar. Developing good habits is the key. For example practise in chunks of 15 minutes and practise every chance you get, do not allow your fingers to do the playing but instead think of what you want to play then play it. It is always best to play in your head first before playing on the guitar. You must have a plan of what you want to do first before doing it and then do it according to the plan.

You must practise to practise then practise, enough said. Goals and plans are meaningless without implementation. At some point I was good at major scales but not so good on minor scales. I started practising minor scales every day in the morning before starting my day, in no time I have mastered the minor scales patterns even mastered the minor scale modes. I have been doing this morning practise ever since, I now have a morning song that I play every morning.

The Sol-fa notation is the best way to start. The Do-Re-Mi-Fa-So-La-Ti-Do[1] is called the Sol-fa notation. I heard about it in a school choir long before I had interest in music. The choir conductor would sing Do-Re-Mi-Fa-So-La-Ti-Do[1] to give the choristers a tuning; yes the conductor tunes the voices of the choristers before they start to sing.

The Sol-fa notation can be compared to the numeral of the number line {0, 1, 2, 3, 4, 5, 6, 7, 8, and 9} in mathematics. Without this numbers arithmetic and calculus or algebra will be impossible.

Do		Re		Mi	Fa		So		La		Ti	Do[1]
1	2	3	4	5	6	7	8	9	10	11	12	1
I		II		III	IV		V		VI		VII	I

For clarity I have labelled the Sol-fa notation in the above diagram with numbers to distinguish the tones and roman numerals to distinguish the notes involved.

Analysing of the Sol-Fa notation going up the pitch.

- Do is the first note and Do1 is the last note, these notes are the same they differ in pitch.
- Re is the second note and it is two steps away from Do as shown by the roman numerals.
- A step is also called a semi-tome, so Re is two semitones away from Do.
- Two semitones make a tone so Re is a tone away from Do.
- Mi is a tone away from Re and two tones away from Do.
- Fa is a semitone away from Mi, three semitone or a tone and a semitone away from Re and five semitones or two tones and a semitone away from Do.
- So is a tone away from Fa, a tone and a semitone away from Mi, two tones and a semitone away from Re and three tones and a semitone away from Do.
- La is a tone away from So, two tones away from Fa, two tones and a semitone away from Mi, three tones and a semitone away from Re and nine semitones away from Do.
- Ti is a tone away from La, two tones away from So, three tones away from Fa, three tones and a semitone away from Mi, four tones and a semitone away from Re and five tones and a semitone away from Do.
- Do1 is a semitone away from Ti, three semitones away from La, five semitones away from So, seven semitones away from Fa, eight semitones away from Mi, ten semitones away from Re and twelve semitones away from Do. Do and Do1 are the same notes they just differ in pitch they are said to be an octave apart. Consider a soprano (female) and a baritone (male) voice singing a note in unison.
- It should be noted that you can also go backward like so Do1-Ti-La-So-Fa-Mi-Re-Do.
- You can also go Do-Re-Mi-Fa-So-La-Ti-Do1-Re1-Mi1-Fa1-So1-La1-Ti1-Do2. This means that you can keep going up or down singing the notes until it is difficult to sing. You can also go up or down using your instruments playing the notes until you run out of notes.

Music Alphabet

Numbers are represented by numerical symbols called numbers starting from 0 to 9 while English words are represented by symbols called alphabets starting A to Z. Music does not used symbols of its own but borrows seven alphabets to represent the seven notes of the Sol-fa notation. The alphabets used in music are A, B, C, D, E, F, and G to cover the twelve possible variation of the Sol-fa notation.

C		D		E	F		G		A		B	C
1	2	3	4	5	6	7	8	9	10	11	12	1

Here I explain the theory behind the notes on the guitar fretboard. Starting from the letter C going from left to right, D is a tone away from C. The note between C and D is called C# pronounced C sharp or D♭ pronounced D flat. .This note has two names. C# (or D♭) is called an enharmonic note since it has two

names. There are five enharmonic notes in music spread out systematically on the guitar fretboard. Enharmonic notes are also called accidentals. The sharps or flats have the same status as the other notes.

E is a tone away from D and two tones away from C. The note between D and E is called D# (or E♭). F is a semi-tone away from E. F is a tone and a semi-tone away from D and two tones and a semi-tone away from C.

G is a tone away from F; A is a tone away from G while B is also a tone away from A. C is a semitone away from B. Although the enharmonic notes like D# or E♭ are referring to the same note in other instances it is preferable to use one name than the other.

By filling in only using sharp enharmonic notes we get. This is normally done when ascending the scale.

C	C#	D	D#	E	F	F#	G	G#	A	A#	B	C
1	2	3	4	5	6	7	8	9	10	11	12	1

By filling in only using flat enharmonic notes we get. This is normally done when descending the scale.

C	Db	D	Eb	E	F	Gb	G	Ab	A	Bb	B	C
1	2	3	4	5	6	7	8	9	10	11	12	1

There are five enharmonic notes and seven notes totalling twelve notes covering all possible variations in music. This means that there are twelve variations of the Do-Re-Mi-Fa-So-La-Ti-Do[1] one for each note of the five enharmonic notes and one for each of the seven notes.

The Do-Re-Mi-Fa-So-La-Ti-Do[1] is commonly called a scale or a key. There are twelve scales or keys in music covering all the songs that have been and will ever be.

Do		Re		Mi	Fa		So		La		Ti	Do¹
1	2	3	4	5	6	7	8	9	10	11	12	1
I		II		III	IV		V		VI		VII	I
C		D		E	F		G		A		B	C
G		A		B	C		D		E		F#	G
D		E		F#	G		A		B		C#	D
A		B		C#	D		E		F#		G#	A
E		F#		G#	A		B		C#		D#	E
B		C#		D	E		F#		G#		A#	B
F#		G#		A#	B		C#		D#		E#	F#
C#		D#		E#	F#		G#		A#		B#	C#

The twelve keys of music

Since music is made up of the twelve scales it becomes obvious that mastering the twelve scales is like mastering music itself.

TIP: Practise all twelve scales in one sitting every time you practise the scales.

Writing Music

Music is written using staff notation, a method that combines various symbols to represent sound. Music notation has been around for more than three hundred years and has evolved with the times to be what it is today.

C major Scale Ascending and Descending

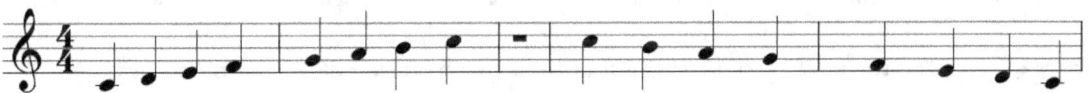

The Staff

The staff is a group of five vertical lines called leger lines and the four spaces between them to form a unit. Music is then written as dots or slashes called notes on the lines or in the spaces.

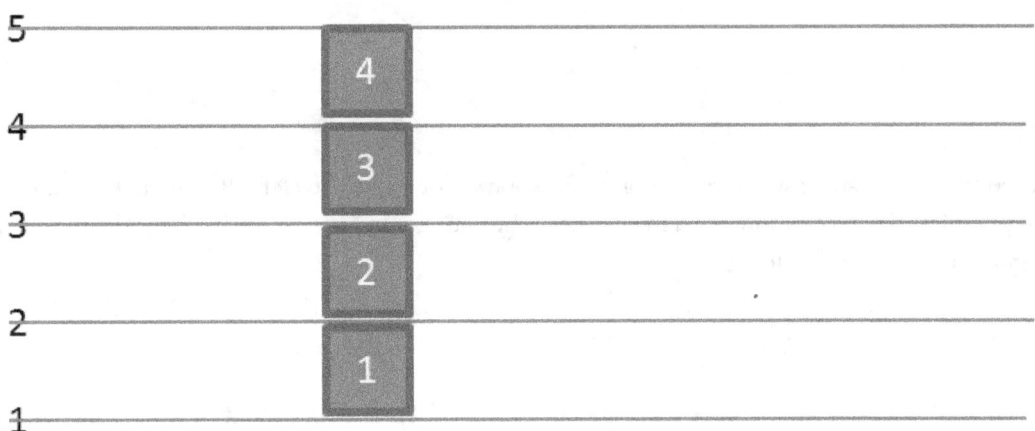

Each of the horizontal lines represents a specific note and each of the spaces between the lines represents also another specific note that is fixed. For example on the treble clef line number one represents the note E so any marking on the first line will require the sounding of the E note. From line one to line five the notes increase in pitch. Line two represent the note G, line three represent the note B, line four represent the note D and line five represent the note F. Extra lines can be added above or below on the fixed ledger lines to extend the scope of writing higher or lower notes.

Note Value

The notes are not all the same in duration. Some notes are sustained while others are played for a short duration. Note value determines the time or the duration at which a note can be sounded. The note value duration has an equivalent rest. A rest is a period where notes are not sounded. Below is a list of the rest followed by a note equivalent to the rest.

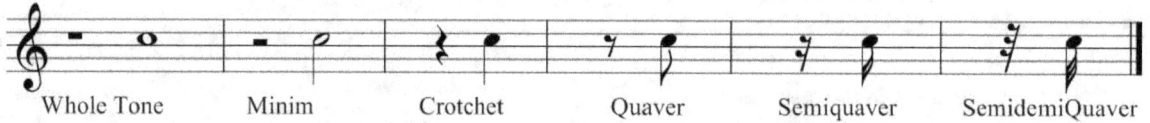
Whole Tone Minim Crotchet Quaver Semiquaver SemidemiQuaver

Below are different representations of playing a four beats in a bar using different note values.

Four Beats in a Bar using Different Note Values

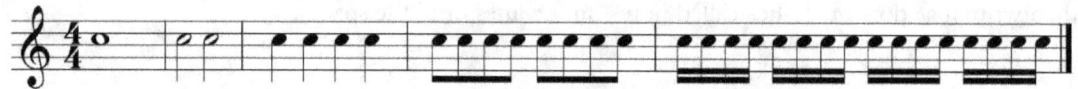

Clefs

Clefs are used to distinguish between music voices for soprano or bass. The clef tells whether you are going to use high pitch female voice or low pitch male voice. The four common clefs are Treble, Alto, Tenor and Bass. The guitar uses the treble clef.

Time Signature

Time signature indicates how many notes to play in a bar. A bar is fixed period on the staff separated by bar lines. In a 4/4 time you play fours crotchets in a bar. The 4/4 is called the time signature. This is like saying you clap your hands several times but in groups of four equal claps.

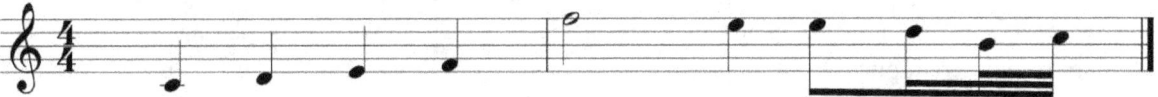

In a 3/4 time you play three crotchets in a bar. This is like saying you clap your hands several times but you clap three times in groups of four claps.

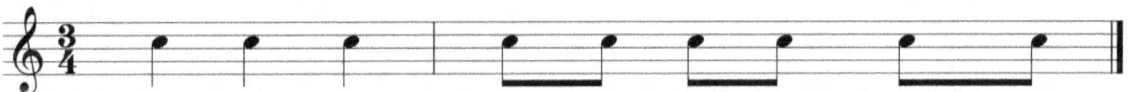

In a 6/8 time you play three quavers in a bar. The 6/8 time is double the speed of the 3/4 time, that is you play the same number of claps in half the time of the 3/4 and smaller notes values are used.

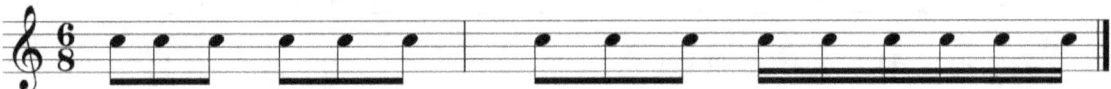

I liken the time signature with frequency. This is to say how many cycles or vibrations you have in a second.

Music Theory

Music theory is the set of rules that explains how music works including how it is written. Music theory is universal; it applies to all forms and genres of music. Music theory deals with the basic and advanced music elements such as beat, rhythm, melody, harmony, timbre, expression, structure, et cetera.

Pitch

In music the pitch refers to the frequency of a note, how high or how low the note sounds. The pitch is a subjective sensation meaning that different people perceive pitch differently. Music pitch is standardized. The A above the middle C must vibrate at a frequency of 440 Hz as recommended by the International Standards Organization (ISO). Pitch helps to distinguish between music and noise as pitch is clear and distinguishable. Two music notes can have the same name but different pitches. On the left hand guitar fretboard as you move from the tuning head to the sound box the pitch increases but the music notes move in cycles, as you

reach G you then start again from A but the pitch increases. If two notes have the same pitch then they are the same in every respect.

Scales

A scale is a well-defined sequence of music notes. The notes of the scale are well arranged according to pitch and in most scales the first and last notes of the scale have the same name just different pitches. The same scale can be played starting from different pitches. There are many C notes on the left hand guitar fretboard. If you start on any of these notes and play the Do-Re-Mi-Fa-So-La-Ti-Do1 you will be playing the same scale just starting from different pitch. You can play the scale ascending or descending. There exist many types of scale systems based on how many notes are in the scale and the spacing between the notes. The octatonic scale type uses eight notes and the Sol-fa notation falls under this type. Most of the scales discussed in this book have eight notes.

The Major Scale

The major scale is the most popular and the most commonly used. The major scale is actually the Do-Re-Mi-Fa-So-La-Ti-Do1 we discussed earlier. This scale employs eight notes that can be labelled first, second, third, fouth, fifth, sixth, seventh and eighth.

1		2		3	4		5		6		7	8

In the major scale first and last notes are the same.

1		2		3	4		5		6		7	1

In academic music the notes are labelled using roman numerals;

I		II		III	IV		V		VI		VII	I

It should be noted that the five blank spaces in the scale represent notes that are not under discussion hence do not need to be labelled as they are not part of the scale.

The different notes from the lowest to the highest are given scale degrees based on the position of the note of the scale.

- The First note is called the Tonic.
- The Second note is called the Supertonic.
- The Third note is called the Mediant.
- The Fourth note is called the Subdominant.
- The Fifth note is called the Dominant.
- The Sixth note is called the Submediant.
- The Seventh note is called the Leading note.
- The Eighth note is called the Octave.

The Tonic of the scale is called the root of the scale as it is the first note. All notes are perceived relative to the roots.

I		II		III	IV		V		VI		VII	I
C		D		E	F		G		A		B	C

The C major scale ascending in tabular form

I		VII		VI		V		IV	III		II		I
C		B		A		G		F	E		D		C

The C major scale descending in tabular form

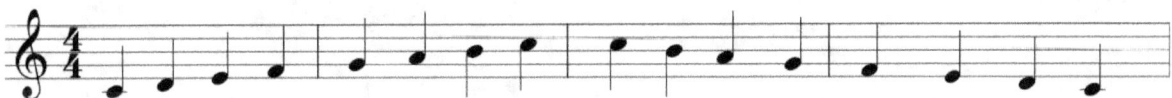

C major scale ascending and descending in staff notation.

Circle of Fifth

The circle of fifth is a systematic method of scale analysis and comprehension. It distinguishes scales based on the number of sharp (#) accidentals that are contained within the scale. For example the C major scale has no accidentals while the G major scale has one accidental, the accidental is F#.

The circle of fifth is based on the simple method of moving from one scale to the next by building the next scale from the fifth of the current scale. Starting from the scale of C we observe that G is the fifth note of C, we then build the new scale G and G will have one sharp. The next scale will be D major scale since it is the fifth of G.

I		II		III	IV		V		VI		VII	I
C		D		E	F		G		A		B	C
G		A		B	C		D		E		F#	G
D		E		F#	G		A		B		C#	D
A		B		C#	D		E		F#		G#	A
E		F#		G#	A		B		C#		D#	E
B		C#		D#	E		F#		G#		A#	B
F#		G#		A#	B		C#		D#		E#	F#
C#		D#		E#	F#		G#		A#		B#	C#

Circle of fifths chart.

Circle of Fouth

The circle of fourth is similar to the circle of fifth except that in the circle of fouth we build the next scale base on the fouth note of the current scale. The circle of fourth distinguishes scales based on the number of flats (♭) that the scale has.

Starting from C the fouth note is F therefore the F major is our next scale. F major has one flat, and the flat is B♭. B♭ is the fourth note of F so the next scale is B♭. B♭ has two flats.

I	II	III	IV	V	VI	VII	I
Cb	Db	Eb	Fb	Gb	Ab	Bb	Cb
Gb	Ab	Bb	Cb	Db	Eb	F	Gb
Db	Eb	F	Gb	Ab	Bb	C	Db
Ab	Bb	C	Db	Eb	F	G	Ab
Eb	F	G	Ab	Bb	C	D	Eb
Bb	C	D	Eb	F	G	A	Bb
F	G	A	Bb	C	D	E	F
C	D	E	F	G	A	B	C

Circle of fourths.

Circle of Keys

In the circle of keys starting from C going up you get the circle of fourths while starting from the C going down you get the circle of fifth. The circle of keys is a tool that can be used to learn scales.

I	II	III	IV	V	VI	VII	I
Cb	Db	Eb	Fb	Gb	Ab	Bb	Cb
Gb	Ab	Bb	Cb	Db	Eb	F	Gb
Db	Eb	F	Gb	Ab	Bb	C	Db
Ab	Bb	C	Db	Eb	F	G	Ab
Eb	F	G	Ab	Bb	C	D	Eb
Bb	C	D	Eb	F	G	A	Bb
F	G	A	Bb	C	D	E	F
C	D	E	F	G	A	B	C
G	A	B	C	D	E	F#	G
D	E	F#	G	A	B	C#	D
A	B	C#	D	E	F#	G#	A
E	F#	G#	A	B	C#	D#	E
B	C#	D#	E	F#	G#	A#	B
F#	G#	A#	B	C#	D#	E#	F#
C#	D#	E#	F#	G#	A#	B#	C#
I	II	III	IV	V	VI	VII	I

The circle of fourths and the circle of fifths can be used jointly to produce the circle of keys.

From C going up you get the circle of fifths while if you are going down from C you get the circle of fourths.

The Minor Scale

The minor scale is also an octatonic scale type as it uses eight notes. While the major scale produces a happy lively sound the minor scale has a bluesy or sad feeling. There are three different types of the minor scale namely the natural minor, the harmonic minor and the melodic minor.

The Natural Minor Scale

The natural minor scale is derived from the major scale. Every natural minor scale has it relative major scale. The natural minor scale and its relative major scale share the same notes. The striking difference is the root note of the scale. For example the A natural minor scale has the same notes as the C major scale.

i		ii	III		iv		v	VI		vii		I
A		B	C		D		E	F		G		A

A natural minor scale is the relative minor scale of C major scale and C major scale is the relative major of the A minor scale. Both the A natural minor and the C major scale have no sharps or flats.

- A is the first note and is called the Tonic.
- B is the second note and is called the Supertonic.
- C is the third note and is called the Mediant.
- D is the fourth note and is called the Subdominant.
- E is the fifth note and is called the Dominant.
- F is the sixth note and is called the Submediant.
- G is the seventh note and is called the Leading.
- A¹ is the eighth note and is called the Octave.

There are twelve natural minor scales corresponding to the twelve major scales.

i		ii	III		iv		v	VI		VII		i
A		B	C		D		E	F		G		A

A minor scale chart

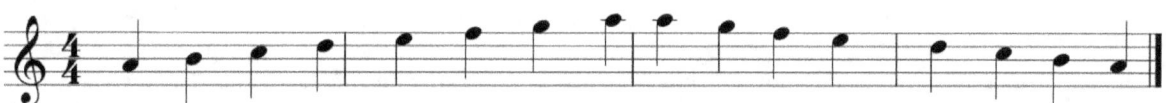

The A natural minor scale on staff notation

The Harmonic Minor

The harmonic minor scale is derived from the natural minor scale. The harmonic minor scale is formed by raising the leading note of the natural minor scale. The leading note of the harmonic minor is raised only when ascending the scale. The C harmonic minor scale is the same as the natural minor scale when descending. This means that the harmonic minor scale is different when ascending to when descending. The harmonic minor scale is used to create harmony, it is seldom used for melody or soloing in choral music as the interval between the VI and the VII is hard to sing.

i		ii	III		iv		v	VI			vii		i
C		D	E♭		F		G	A♭			B		C

A harmonic minor scale chart

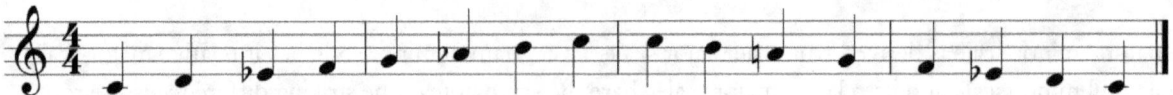

Ascending and descending C harmonic minor on the staff notation

The Melodic Minor

The melodic minor scale is derived from the ascending harmonic minor scale. The melodic minor scale is formed by raising the VI note of the ascending harmonic minor scale by a semi tone. The VI note of the melodic minor is raised when ascending and also when descending. The melodic minor is the same when ascending and when descending. The melodic minor scale is used to create melody and can be used soloing.

i	ii	III	iv	v	VI	vii	i
C	D	E♭	F	G	A	B	C

C melodic minor chart

The melodic minor can be thought of as the major scale with a flattened third.

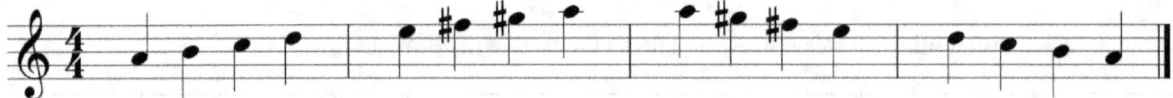

A melodic minor on the staff notation

Modes of the Major Scale

The C major scale uses seven distinct notes. It has been also noted that when you start the C major scale from the A note you create another scale called the A natural minor scale. We can also say that the A natural minor is another mode of C since it has the same notes but differ in the root note. By making every other notes of the C major scale a starting point you create another mode of the C major scale. The C major scale has seven different notes therefore seven modes can be created on the C major scale by making each note on the scale a root.

Ionian	C	D	E	F	G	A	B	C
Dorian	D	E	F	G	A	B	C	D
Phyrigian	E	F	G	A	B	C	D	E
Lydian	F	G	A	B	C	D	E	F
Mixolydian	G	A	B	C	D	E	F	G
Aeolonian	A	B	C	D	E	F	G	A
Locrian	B	C	D	E	F	G	A	B

C major scale modes chart

If we transpose the other modes to have their root as C we get the following as shown below.

Ionian	C	D	E	F	G	A	B	C
Dorian	C	D	Eb	F	G	A	Bb	C
Phyrigian	C	Db	Eb	F	G	Ab	Bb	C
Lydian	C	D	E	F#	G	A	B	C
Mixolydian	C	D	E	F	G	A	Bb	C
Aeolonian	C	D	Eb	F	G	Ab	Bb	C
Locrian	C	Db	Eb	F	Gb	Ab	Bb	C

Major scale modes using C as the root chart

Other Scales

The scales discussed so far are by no means the only available scales in music. African, Arabic, Chinese and other scales exist and they are beyond the scope of this book. The blues and pentatonic scales are by far the most common scales used for soloing and melody creation however they fall outside the common eight notes scales.

The diminished scale is one of the eight note scale so important that completing this book without it will be doing injustice to the left hand guitarist.

Major Pentatonic Scale

The pentatonic scale has its origin from folk music. The major pentatonic scale is composed of five notes taken from the major scale. The major pentatonic scale can be considered as a major scale without the fourth and the seven notes of the scale.

I		II		III			V		VI			I
C		D		E			G		A			C

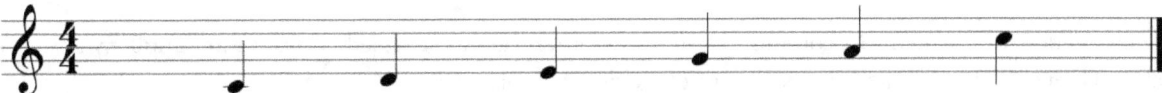

The major pentatonic scale is used to solo over major and dominant chords. The pentatonic scale is a form of an advanced improvisation method. It is useful when you use pattern form for example .III-VI-V-II-III-V. When applied on the C major pentatonic it becomes D-A-G-D-E-G.

Minor Pentatonic Scale

The minor pentatonic scale is derived from the natural minor scale. To form the minor pentatonic take the natural minor scale and remove the second and the sixth notes from the scale.

i			III	iv	v			VII		i
A			C	D	E			G		A

A minor pentatonic scale chart

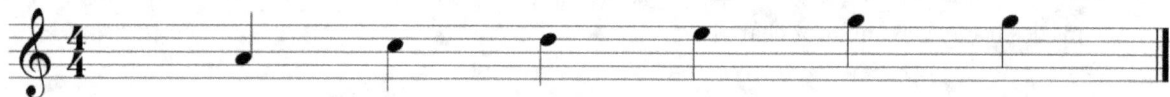

The minor pentatonic scale on the staff notation

Major Blues Scale

The origins of the blues scale dates back to Africans who were brought to America as slaves. The major blues scale is not as popular as the minor blues.

C		D	Eb	E			G		A			C

The major blues scale chart

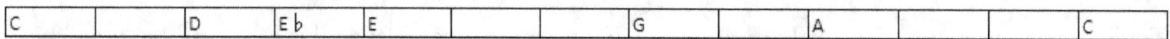

The major blues scale staff notation

The major blues scale can be use over blues progressions. For instance play the C major blues over C7 and play G major blues over G7. The blues progression mostly uses seventh chords. The major blues can be used to improvise over dominant chords not in a blues progression.

Minor Blues Scale

The minor blues scale is the most commonly used scales after the major scale because of its simplicity and usability. The minor blues scale sounds vibrant every time you play it.

C			Eb		F	F#	G			Bb		C

The C minor blues scale

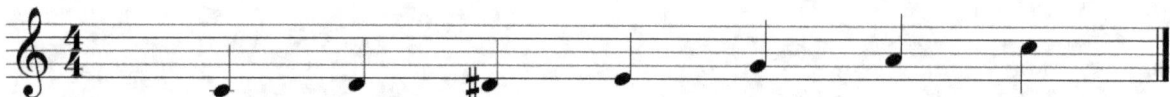

The F# can be replaced by the G♭ since they are enharmonic notes

C			Eb		F	Gb	G			Bb		C

The C minor blues scale

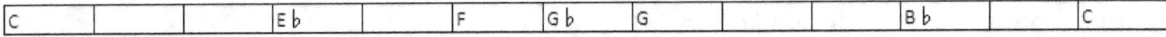

The C minor blues staff notation

The minor blues scale can be used as a substitute to the pentatonic minor scale. The minor pentatonic scale can also be formed by removing the G♭ from the blue scale.

The Diminished Scale

There are two types of diminished scale. The tone-semitone and the semitone-tone diminished scale.

A		B	C		D	Eb		F	Gb		Ab	A

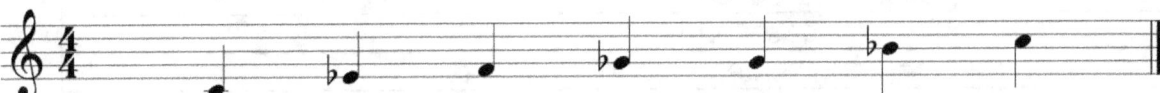

The diminished scale tone semi-tone staff notation

The tone-semitone diminished scale starts with a tone followed by a semitone. It is often referred to as the WHWHWHWH where W is for whole tone and H is for half tone or semitone.

B	C		D	Eb		F	Gb		Ab	A		B

Tone semi-tone diminished scale

The semitone-tone diminished scale starts with a semitone followed by a tone. It is often referred to as the HWHWHWHW where H is for half tone or semitone and W is for whole tone.

Improvisation

Improvisation is closely related to soloing. Soloing is melody played with or without accompaniment. The melody is referred to as a solo. I define improvisation as an advanced or abstract way of soloing that is used extensively in modern music such as Jazz and heavy metal rock.

Scales are the basis of understanding how to improvise. Intervals, triads and chords are other important components that help the left hand guitarist master the art of improvisation.

Intervals

The distance between any two notes is called an interval. An interval can be thought of as how many notes or semitones can you insert between any two given notes. In the smallest interval you cannot insert any notes between the two notes under discussion.

Distance from	To	Interval Name
C	C	unison
C	C#	minor second
C	D	major second
C	D#	augmented second or minor third
C	E	major third
C	F	perfect fourth
C	F#	augmented fourth or diminished fifth
C	G	perfect fifth
C	G#	augmented fifth
C	A	major six
C	A#	minor seventh
C	B	major seventh
C	C^1	Perfect octave
C	C#	minor ninth
C	D	major ninth
C	D#	augmented nine
C	E	major ten
C	F	eleventh
C	F#	augmented eleventh
C	G	perfect twelfth
C	G#	augmented twelfth
C	A	major thirteenth
C	A#	minor fourteenth
C	B	major fourteen
C	C^2	perfect double octave

Triads

A triad is the simplest form of a chord. A triad is constructed by logically stacking three or more notes together as a set and playing them all together or in succession. If the notes of a triad are played in succession one after another the triad is called an arpeggio and the sound creates melody. If the stack of notes is played at ones the triad is called a chord and it creates harmony.

I	II	III	IV	V	VI	VII	I
C	D	E	F	G	A	B	C

The C major scale chart

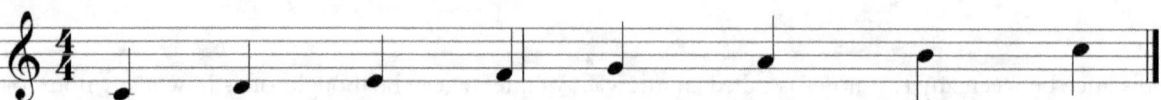

The C major scale staff notation

The C major triad is constructed by stacking the I, III and the V notes of the C major scale and use them as a unit. The C major triad has C, E and G strictly in that order. It should also be noted that the interval between C and E is a major third, the interval between C and G is a perfect fifth while the interval between E and G is a minor third.

I		II		III	IV		V		VI		VII	I
C		D		E	F		G		A		B	C
E		F		G	A		B		C		D	E
G		A		B	C		D		E		F	G

The C major scale triads chart

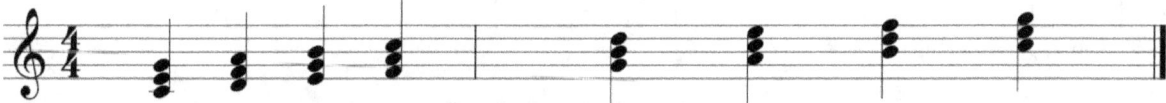

The C major scale staff notation

The D minor triad is constructed by stacking the II, IV and VI notes on the C major scale. The D minor triad thus has D, F and A. The interval between D and F is a minor third, the interval between D and A is a major fifth and the interval between F and A is a major third.

The E minor triad is formed by taking the III, V and the VII notes of the C major scale. The E minor triad thus has E, G and B as its constituent notes. The interval between E and G is a minor interval, the interval between E and B is a perfect fifth and the interval between G and B is a major third interval.

The F major triad has IV, VI and VIII notes of the C major scale. The F major triad has the F, A and C as its constituent notes. The interval between F and A is a major interval, the interval between F and C is a perfect fifth and the interval between A and C is a minor third interval.

The G major triad is formed on the fifth note of the C major scale. The G major triad is formed by stacking the V, VII and the II notes together and the resulting notes are G, B and D. The interval between G and B is a major third, the interval between G and D is a perfect fifth and the interval between B and D is a minor third interval.

The A minor triad is formed by stacking the VI, VIII and the III notes of the C major scale. The A minor is composed of A, C and E. The interval between A and C is a minor third, the interval between A and E is a perfect fifth while the interval between C and E is a major third.

The B diminished triad is formed by stacking the VII, II and IV notes of the C major scale. The B diminished triad is thus composed of B, D and F. The interval between B and D is a minor third interval, the interval between B and F is a diminished fifth and the interval between D and F is a minor third interval.

Triad Families

Triads are classified under four distinct families namely the major triads, minor triads, diminished triads and augmented triads. The first and the fifth notes are a perfect fifth apart.

The Major Triad Family

The major triad is formed by stacking a major and a minor interval together. This means that the first note and the second note are a major interval apart while the second and the third note are a minor interval apart.

In C major scale the major triad are formed on the first, fourth and fifth notes of the scale.

I	II	III	IV	V	VI	VII	I
C			F	G			C
E			A	B			E
G			C	D			G

C major primary triads chart

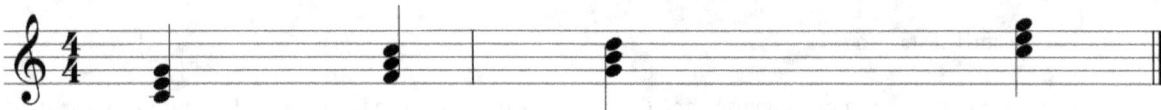

C major primary triads staff notation

Minor Triad Family

The minor triad is formed by stacking a minor interval followed by a major interval. The interval between the first note and the second note is a minor interval while the interval between the second note and the third note is a major interval.

On the C major scale the minor triads are formed on the second, third and sixth notes of the scale.

I	II	III	IV	V	VI	VII	I
	D	E			A		
	F	G			C		
	A	B			E		

C major secondary triads chart

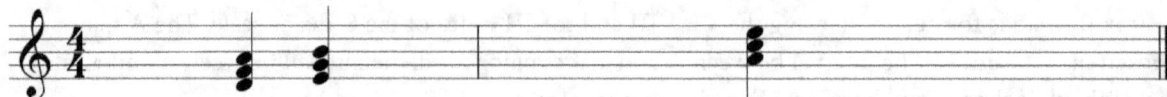

The C major scale staff notation

Diminished Triad Family

The diminished triad is formed by stacking the minor interval followed by a minor interval. The diminished triad is formed by staking two minor intervals together. The interval between the first note and the second note is a minor interval and the interval between the second note and the third note is also a minor interval.

On the C major scale the diminished triad is formed on the seventh degree of the scale.

I	II	III	IV	V	VI	VII	I
						B	
						D	
						F	

The C major scale diminished triad chart

The C major scale diminished triad staff notation

The Augmented Triad Family

The augmented triad is formed by staking two major intervals together. The interval between the first and the second notes is a major interval and the interval between the second note and the third note is a major interval. The augmented interval does not exist on any of the triads formed on the C major scale. The augmented triad is found on the harmonic minor scale. The augmented triad is often called the augmented fifth.

The augmented triad of the C harmonic minor scale staff notation

Triads Formed on the Natural Minor Scale

The triads formed on the minor scale are the same as the triads formed on the major scale. Since the major scale has its relative minor scale, by the same way the major scale triads have their relative minor scale triads.

i	ii	III	iv	v	VI	VII	i
A	B	C	D	E	F	G	A
C	D	E	F	G	A	B	C
E	F	G	A	B	C	D	E

Natural minor scale triads chart

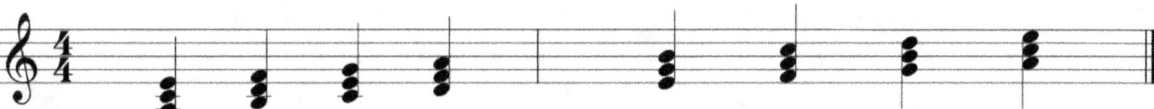

Natural minor scale triads staff notation

The triads formed on the A natural minor scale are named as follows;

- The triad formed on the first note A is an A minor.
- The triad formed on the second note B is B diminished.
- The triad formed on the third note C is a C major.
- The triad formed on the fourth note D is D minor.

- The triad formed on the fifth note E is E minor.
- The triad formed on the sixth note F is F major.
- The triad formed on the seventh note G is G major.
- The triad formed on the last note A is A minor.

Triads Formed on the Harmonic Minor Scale

i	ii	III	iv	v	VI	vii	i
C	D	E♭	F	G	A♭	B	C
E♭	F	G	A♭	B	C	D	E♭
G	A♭	B	C	D	E♭	F	G

C Harmonic minor triads chart

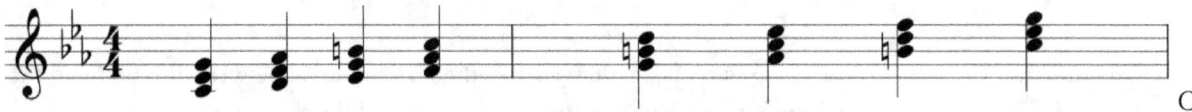

Harmonic minor triads staff notation

The triads formed on the C harmonic minor scale are named as follows;

- The triad formed on the first note C is C minor.
- The triad formed on the second note D is D diminished.
- The triad formed on the third note E♭ is E♭ augmented.
- The triad formed on the fourth note F is F minor.
- The triad formed on the fifth note G is G major.
- The triad formed on the sixth note A♭ is A♭ major.
- The triad formed on the seventh note B is B diminished.
- The triad formed on the last note C is C minor.

Triads Formed on the Melodic Minor Scale

i	ii	III	iv	v	VI	vii	i
C	D	E♭	F	G	A	B	C
E♭	F	G	A	B	C	D	E♭
G	A	B	C	D	E	F	G

Melodic minor scale triads chart

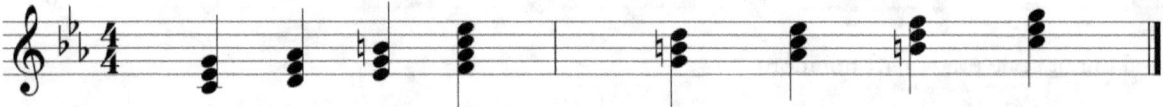

Melodic minor scale triads

The triads formed on the C melodic minor scale are named as follows;

- The triad formed on the first note C is C minor.
- The triad formed on the second note D is D minor.

- The triad formed on the third note E♭ is E♭ augmented.
- The triad formed on the fourth note F is F major.
- The triad formed on the fifth note G is G major.
- The triad formed on the sixth note A is A minor.
- The triad formed on the seventh note B is B diminished.
- The triad formed on the last note C is C minor.

Triads with Seventh Notes

It is to be noted that the order of notes in a triad is strictly as explained above. The triads discussed so far are three notes triads. A seventh interval from the root of the triad can be added onto the triad to form a four notes triad. The seventh interval can be major seven or minor seven. The resulting sub-families are major seventh triads, minor seventh triads, diminished seven triads, minor seventh flat five triads, major seventh sharp five triads, minor major seventh and the dominant seventh triad not name but a few.

Major Scale Triads with an Added Seventh

The stacking of notes to form a triad is dictated by the notes of the underlying scale. For instance the C major scale does not have sharps of flats as a result the triads formed on the major scale should have no sharps or flats.

A major seventh interval is added on the major triad, a minor seventh interval is added on the minor interval and a diminished interval is added on the diminished interval. The augmented interval is added with a major seventh interval to form a major seven sharp five. The dominant interval is a result of adding a minor seventh over a major interval.

I	II	III	IV	V	VI	VII	I
C	D	E	F	G	A	B	C
E	F	G	A	B	C	D	E
G	A	B	C	D	E	F	G
B	C	D	E	F	G	A	B

C major scale seventh triads chart

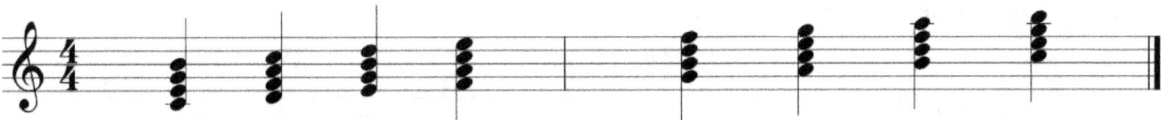

C major scale seventh triads

The seventh triads formed on the C major scale are named as follows;

- The seventh triad formed on the first note C is C major seven written C7+.
- The seventh triad formed on the second note D is D minor seven written Dm7.
- The seventh triad formed on the third note E is E minor seven written Em7.
- The seventh triad formed on the fourth note F is F major seven written F7+.
- The seventh triad formed on the fifth note G is G dominant seven written G7.

- The seventh triad formed on the sixth note A is an A minor seven written Am7.
- The seventh triad formed on the seventh note B is B diminished seven written Bdim7.
- The seventh triad formed on the last note C is C major seven written C7+.

Natural Minor Scale Triads with an Added Seventh

The seventh triads formed on the natural minor scale are the same as the triads formed on the major scale except that the first triad in C major is C major seven while the first triad in A natural minor is A minor seven.

i	ii	III	iv	v	VI	VII	i
A	B	C	D	E	F	G	A
C	D	E	F	G	A	B	C
E	F	G	A	B	C	D	E
G	A	B	C	D	E	F	G

The A natural minor triads with seventh chart

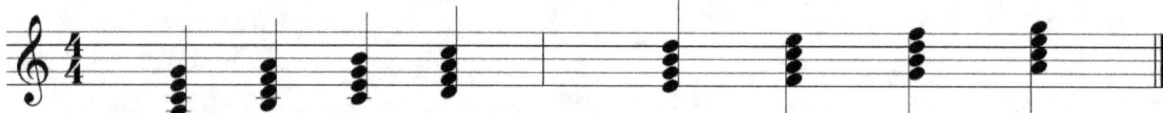

The A natural minor triads with seventh

- The seventh triad formed on the first note A is an A minor seven written Am7.
- The seventh triad formed on the second note B is B diminished seven written Bdim7.
- The seventh triad formed on the third note C is C major seven written C7+.
- The seventh triad formed on the fourth note D is D minor seven written Dm7.
- The seventh triad formed on the fifth note E is E minor seven written Em7.
- The seventh triad formed on the sixth note F is F major seven written F7+.
- The seventh triad formed on the seventh note G is G dominant seven written G7.
- The seventh triad formed on the last note A is an A minor seven written Am7.

Harmonic Minor Triads with an Added Seventh

i	ii	III	iv	v	VI	vii	i
C	D	E♭	F	G	A♭	B	C
E♭	F	G	A♭	B	C	D	E♭
G	A♭	B	C	D	E♭	F	G
B	C	D	E♭	F	G	A♭	B

The C harmonic minor scale triads chart

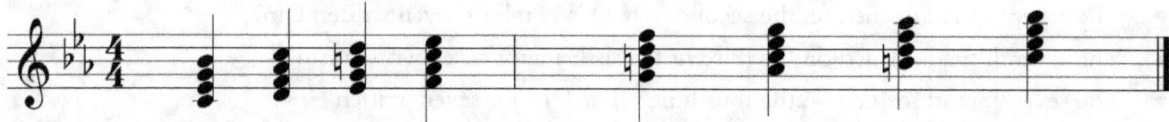

The C harmonic minor scale triads staff notation

The seventh triads formed on the C harmonic minor scale are named as follows;

- The seventh triad formed on the first note C is C minor major seven written Cm7+.
- The seventh triad formed on the second note D is D minor seven flat five written Dm7-5.
- The seventh triad formed on the third note E♭ is E♭ major seven augmented fifth written as E♭ maj 7 +5 or E♭ M 7 +5.
- The seventh triad formed on the fourth note F is F minor seven written Fm7.
- The seventh triad formed on the fifth note G is G dominant seven written G7.
- The seventh triad formed on the sixth note A is an A major seven written A7+.
- The seventh triad formed on the seventh note B is B diminished seven written Bdim7.
- The seventh triad formed on the last note C is C major seven written C7+.

Melodic Minor Triads with Added Seventh

i		ii	III		iv		v		VI		vii	i
C		D	E♭		F		G		A		B	C
E♭		F	G		A		B		C		D	E♭
G		A	B		C		D		E♭		F	G
B		C	D		E♭		F		G		A	B

The melodic minor scale triads chart

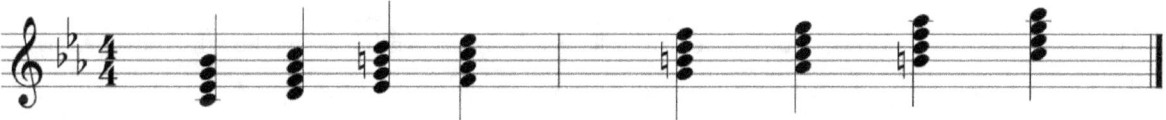

The melodic minor scale triads

The seventh triads formed on the C melodic minor scale are named as follows;

- The seventh triad formed on the first note C is C minor major seven Cm7+.
- The seventh triad formed on the second note D is D minor seven Dm7.
- The seventh triad formed on the third note E♭ is E♭ major seven augmented fifth written E♭M7+5 or E♭ Maj7+5.
- The seventh triad formed on the fourth note F is F dominant seven written F7.
- The seventh triad formed on the fifth note G is G dominant seven written G7.
- The seventh triad formed on the sixth note A is an A minor seven flat five written Am7-5.
- The seventh triad formed on the seventh note B is B diminished seven written Bm7-5.
- The seventh triad formed on the first note C is C minor major seven Cm7+.

Triad Inversion

The triad we have discussed so far are triads in root position. A triad in root position has the root followed the third and the third followed the fifth strictly in that order.

A four note triad in root position has the root followed by the third, followed by the fifth and then the seventh strictly in that order.

First Inversion

The three notes triads in first inversion have the third followed by the fifth and then the root strictly in that order.

The four notes triad in first inversion has the third followed by the fifth, followed by the seventh then followed by the root.

Second Inversion

A three note triad in second inversion has its fifth, followed by the root and then the third strictly in that order.

The four note triad in second inversion has the fifth followed by the seventh, followed by the root then by the third.

Third Inversion

The three notes triad does not have a third inversion. The third inversion applies to four or more notes triads.

The four note triad has the seventh, followed by the root, followed by the third and followed by the fifth strictly in that order.

Creating Chords from Triads

All triads are chords but not all chords are triads. A triad consist of distinct notes in a specific order while a chord consists of notes in any order. The notes in a chord can be duplicated for example you can have two root notes while the notes in a triad cannot be duplicated you can have only one note of each.

A chord is a set of three or more notes grouped together to form a unit and played together or as an arpeggio. To form a chord from a three note arpeggio simply double any of the three notes of the basic triad preferably the root. One of the doubled note should preferable be in the upper strings and the other on the lower strings.

Guitar Chords

The left hand guitar has six strings and a basic triad has three notes this suggests that you can double all the notes in the triad to form a left hand guitar chord. Doubling procedure suggest that you double the root for major triads and double the third for minor. You may omit the fifth of a major without affecting the quality of the chord but then you must repeat the first note three times. The root may be sometimes omitted given that it is played by another instrument.

Chords form the basis of harmony in music. The approach and use of chords differs in every music genre. In African and gospel music simple major or minor chords are used as an accompaniment to a soloist, solo instrument like saxophone or to a choir. In jazz music chords are used as part of soloing and improvisation and most often complex chords like thirteens and major seven flat nine are used. The strumming of the chord often determines the genre for instance in reggae music simple three chords are used as the basis for the complex bass line. All musical instruments can play arpeggios but only few instruments like piano and guitar can play chords. Chords can also be played by four or more instruments playing different voices simultaneously as in four part harmony for example orchestra or music ensemble.

Basic Left Hand Guitar Chords

No separate literature exists for left hand guitar chords. Like in reading and writing the left hand must adapt and used his left hand on the right hand guitar world. The left hand must adapt to the western world of writing and reading that is to read the right hand way. What comes to mind is that if something is not right then it is wrong. On the other hand the consolation is that Arabic writing is based on the left hand as you start from left to right.

The C major chord often called C by far is the most common chord if not the most played. As you will notice not all strings are used when playing the guitar so you need to be able to mute or dampen the other strings that you are not using. The strings that are not used are marked with an X.

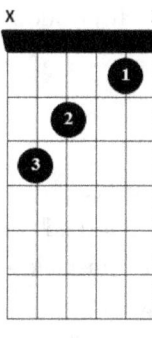

C

Reading the Chord diagram

37

When playing the left hand guitar the left hand is used to strum the strings while the right hand is used to press on the fretboard side of the string. The left hand is also used to hold the pick if you want to use it. Your right fingers are given numbers from one to four. The pointing finger is labelled number one, the index finger is labelled two, the ring finger is labelled three and the baby finger is labelled number four. The thumb is never used.

On the C major chord above; the pointing finger is used on the first fret of the second string, the index finger is used on the second fret of the fourth string and the ring finger is used on the third fret of the fifth string.

Basic Guitar Chords Shapes

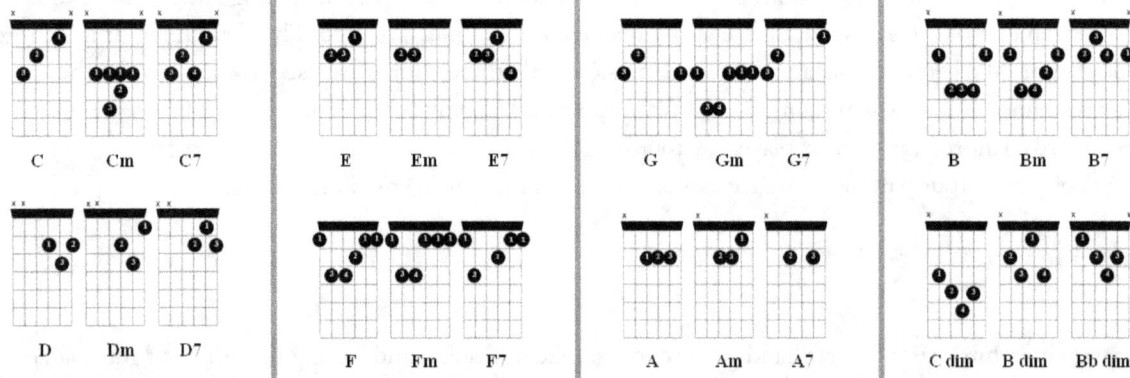

Chords can also be represented using the position of the string on the fretboard. This notation is compact and saves space but it does not show which finger to use on which string. This notation is based on the fact that each string is identified by a number from the smallest 1E, 2B, 3G, 4D, 5A to the largest 6E. Each chord can then be represented by the combination of frets and strings that forms the triad.

The short hand to represent the C major chord (often called C) above is X3201X. The X indicates the string you are not supposed to play. The 3 indicates that you play string number five on the third position; the 2 indicate that you play the third string at position two. The zero between 2 and 1 means that you play an open string for string three. The one indicate that you play position one on string two.

Chord Extensions

Chord extension is based on triad formation. A triad can be extended to enhance it. Other extensions are more preferred than others. For instance the C major triad cannot be extended to an eleventh. The eleventh of C is F, the note F in the C triad makes the chord unstable as the chord will need to resolve the F to E. C as a first triad of the C major scale is stable. In music harmony, cadence is the strict set of rules that governs chord movement and suggests which chord can be resolved to which chord and how.

	4th	6th	7th	9th	11th	13th	6/9
C	Csus4	C6	C7+	C9+			C6/9
Dm		Dm	Dm7	Dm9		Dm13	Dm6/9
Em			Em7		Em11		
F			F7		F7+b5		F6/9
G	Gsus4	G6	G7	G9	G11	G13	G6/9
Am			Am7	Am9	Am11b5		
Bdim			Bm7b5				

Chords extension chart

The first column outlines the C major scale basic triads. The first row outlines all the possible chord extensions. A simple triad normally contains the first, the third and the fifth as a result they are not included as possible extensions. A triad cannot be extended to a fifth since it has a fifth already.

An interesting consequence of triad extensions is that all basic triads can be extended to a seventh. The triad build on the fifth note of the scale in this case G can have all possible extensions. The diminished triad can only be extended to the seventh only.

Chords Progression

Chords progression refers to the movement of one chord to the next to form a song. Chords progression can also be called triads progression. The most common and basic chord progression is based on the movement from the first, then to the fouth, then to the fifth and then back to the first written I-IV-V-I or any combination of these. This progression is often called the 1-4-5 because of the triads used in the scale degrees of the major scale. Any combination of the 1-4-5 will work. For example; 5-4-1, 5-4-5-1, 5-4-5-1, 5-1-4-1, 4-5-4-1, 4-1-5, and so on. A major chord progression is called as such because the progression often is composed of chords on the major scale while a minor chords progression is composed of chords based on the minor scale.

Major Chords Progression	Examples
I – IV – V	C – F – G7
I – ii – V	C7+ – Dm7 – G9
I – vi – ii – V	C7+ – Am7 – Dm7 – G7
I – iii – vi – ii – V	C6 – Em7 – Am7 – Dm7 – G13

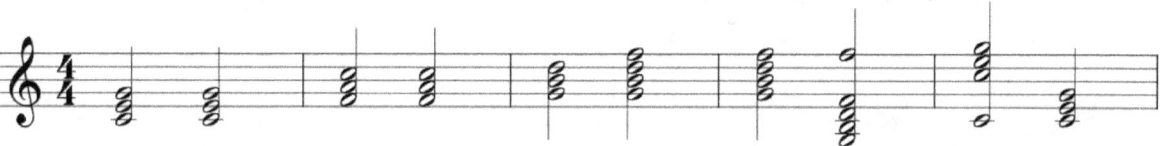

The C - F - G7 chords progression

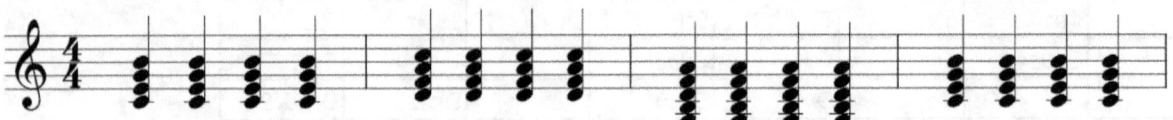

The C7+ - Dm7 - G7 chords progression

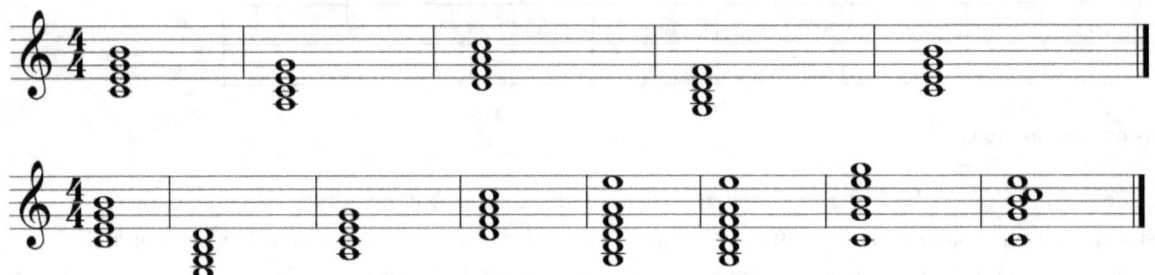

Minor chords progression can be based on the natural, or harmonic or melodic minor scale

minor Chords Progression		Examples
i – iv – v	Natural minor	Cm – Fm7 – Gm
i – ii⁰ – V	Harmonic minor	Cm – Dm7b5 – G9
i – VI⁰ – ii – V	Melodic minor	Cm – Am7b5 – Dm7 – G7
i – bVI – iv – V	Harmonic minor	Cm – Ab7+ – Fm7 – G7b9

Blues chords progressions most often than not use seventh chords. It is safe to say that blues progression is made of dominant chords.

Blues Chords Progression	Examples
I7 – IV7 – V7	C7 – F7 – G7
I7 – IV7 – I7 – I7 – V7 – I7	C7 – F7 – C7 – C7 – G7 – C7
I7 – IV7 – I7 – V7 – I7	C7 – F7 – C7 – G7 – C7

Chords Substitution

Chord substitution in a progression refers to the replacement of one chord by another. The new chord plays the role of the replaced chord.

Basic Chord Substitution

To understand the basics of chord substitution let us consider the triads formed on the C major scale. The C major triad has C, E and G. The E minor triad has E, G, and B. The triad C major and E minor share two notes in common namely E and G. The E minor triad can be used as a substitute for the C major triad. The A minor triad has A, C and E. The A minor triad shares two notes with the C major triad as a result the C

major can be substituted by the A minor triad. A minor triad and E minor triad can be used to substitute the C major triad. The A minor triad is preferred over the E minor triad the reason being that the E minor has the note B that naturally wants to resolve to C.

Using the above method it becomes obvious that the F major triad can be substituted by the D minor triad and the D minor triad can be substituted by the F major triad. The G major triad can be substituted by the B diminished triad and the B diminished triad can be substituted by the G major triad. The C6 triad can be substituted by the A minor seventh triad and the A minor seventh triad can be substituted by the C6 triad.

Useful Chord Substitution

- G7b9 can be substituted by any of the Bdim7, Ddim7, Fdim7 or Abdim7. The G7b9 triad is composed of G, B, D, F and Ab. The Bdim7 triad is composed of B, D, F and Ab. The Ddim7 is composed of D, F, Ab and B. The Fdim7 triad is composed of F, Ab, B and D. The Ab dim is composed of Ab, B, D and F. All the diminished triads mentioned here share the notes G, B, D and Ab which are the notes found in the G7b9.
- Embellishment or direct substitution refers to the addition of the seventh, ninth, eleventh or thirteenth to a triad. Embellishment or direct substitution also refers to the substitution of a chord or triad by its altered version such as b5, #5, b9, #9 and #11.
- Tritone substitution refers to the substitution of a triad that is a tritone away from the current. A tritone is an interval of three tones or six semitones. In a progression G7 could be substituted by Db7. A tritone substitution is also called flat five substitution.
- A13 can be substituted by Eb7#9 because of the following: A13 can substitute A7 or simply A. We can think of the A13 as an A triad. From the tritone substitution A7 can be substituted by Eb7. The Eb7 can then be substituted by the altered form Eb7#9.

Conclusion

Playing the left hand guitar can be very challenging because you have to find the left guitar or rather the left handed guitar let alone an appropriate guitar, or find the right guitar and change the strings. You have to worry if the right hand guitar learning material is good for you. I am glad I did not use books until I was able to play the bass. The fact that I am a leftie in a right hand world made me expect that I have to do some adjusting at whatever I do.

I have opened the book by introducing some of the famous left handed people on the planet. They are famous because they have made great contributions. It may sound arrogant but the lefties are the best people in the world. Tell me of the best scientists I can bet they are lefty. Tell me of the best artists I can bet they are lefty. Tell me of many great persons I can bet they are lefty. Of course even in the music business lefties have played the leading role.

I have introduced the history of the left handed guitar and the guitar in general. Playing the guitar is very challenging but I hope I have challenged the left hand be aware of the techniques that I have used to learn the guitar. I have introduced the sol-fa notation of which I think all music students must know.

I have explored the anatomy of the left hand guitar though I have not venture in the gadgets or synthesizers or peripherals or plugins for the reason that they are a personal preference and I do not used them often as I prefer a clean sound.

I have included some basic fundamentals of reading and writing music. I did not by any means have covered the basic core of reading and writing music. The academic leftie by now will know what to do. For me the sol-fa notation is not academic but then again many critics might say the opposite. Positive criticism is good. Negative criticism is bad but there is some truth to be found. Do not spend any time worrying about what others might think or say just be the best to you. I do not know of any statue that was erected for a critic so be yourself.

For me scales are everything so I have tried to explain the basic fundamental on scales. I believe just practising scales is more than half of the music journey because you play riffs, hammer on, and everything on scales or parts thereof. The intervals within a scale are important bus also easy to learn. Intervals help on you chords construction. You should be able to construct your own chords and use the chords dictionary to find easy fingering of chords.

I have covered in greater detail the extension of chords based on the intervals but I have not said everything about chords extension. A guitarist is an eternal student so learn more especially on the staff you want to master.

Finally I have scratched the surface on chords progress and chords substitution. Experience is the best teacher so experiment, try different thing and find out what works. Relying on learning alone can serve as a limit of the things you can do. I have not attended a show where the musician is asked for a CV with references before they can be heard. I think most the great musicians like Wes Montgomery are self-taught so you are your best teacher.

In the final your playing will depend on you.

www.ingramcontent.com/pod-product-compliance
Lightning Source LLC
Chambersburg PA
CBHW081146170526
45158CB00009BA/2713